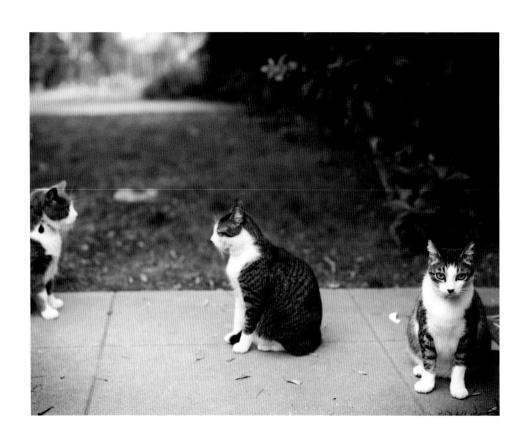

Cationary

meaningful portraits
of cats
by Sharon Montrose

VIKING STUDIO

VIKING STUDIO
Published by the Penguin Group
Penguin Putnam Inc., 375 Hudson Street, New York, New York 10014, U.S.A.
Penguin Books Ltd, 80 Strand, London WC2R ORL, England
Penguin Books Australia Ltd, Ringwood, Victoria, Australia
Penguin Books Canada Ltd, 10 Alcorn Avenue, Toronto, Ontario, Canada M4V 3B2
Penguin Books (N.Z.) Ltd, 182-190 Wairau Road, Auckland 10, New Zealand

Penguin Books Ltd, Registered Offices:
Harmondsworth, Middlesex, England

First published in 2002 by Viking Studio,
a member of Penguin Putnam Inc.

10 9 8 7 6 5 4 3 2 1

Copyright © Sharon Montrose, 2002
All rights reserved

CIP data available

ISBN 0-670-03059-7

This book is printed on acid-free paper. ∞

Printed in Japan

Set in Catlover
Designed by Sharon Montrose

PRONUNCIATION KEY

ə a in collar
 e in litter
 i in fragile
 o in vision
 u in curious

a bath, bask
ā play, spray
ä snob, arch

b bowl, kibble

ch scratch, chase

d indoor, outdoor

e bed, scent
ē clean, sleep

f flea, friend

g groom, grow

h hunt, hide

i sniff, kiss
ī wild, hide

j jolly, jump

k milk, stalk

l claw, lick

m meow, climb

n feline, nap
ŋ drink, wink

ō domestic, calico
ô ignore, soft

oo good, furious
ōō chew, food

oi toy, joy
ou bounce, pounce

p pet, happy

r run, treat

s stare, hiss
sh shed, dish

t tabby, tag
th think, warmth

u rub, fluffy
ʉr perch, purr

v vocal, love

w water, whisker

y yarn, yawn

z lazy, crazy

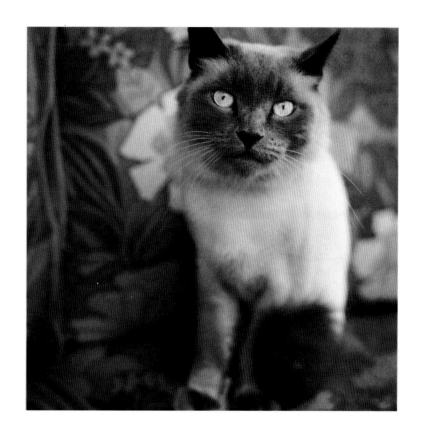

ANGEL

(an'gəl)n.

1. a kind heart

2. a sweet heart

3. a tender heart

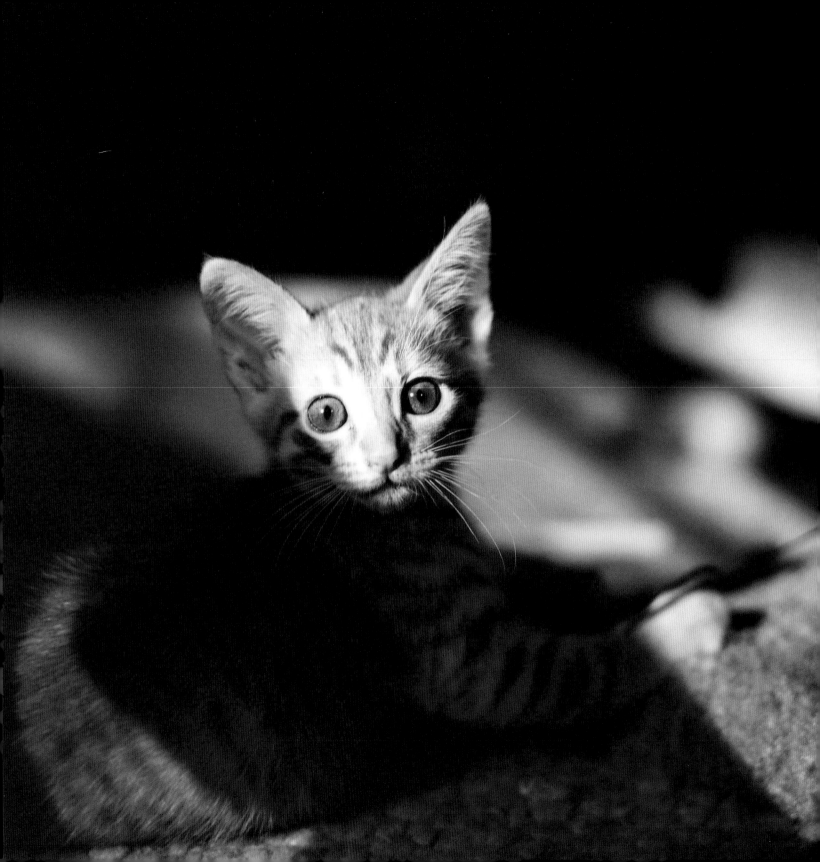

APPLE
(ap'əl)n.

1. HATES the dark 2. LIKES the shade

3. LOVES the SUN

ASPARAGUS
(ə spar'ə gəs)n.

1. a kitty

2. a panther

3. a KING of the JUNGLE

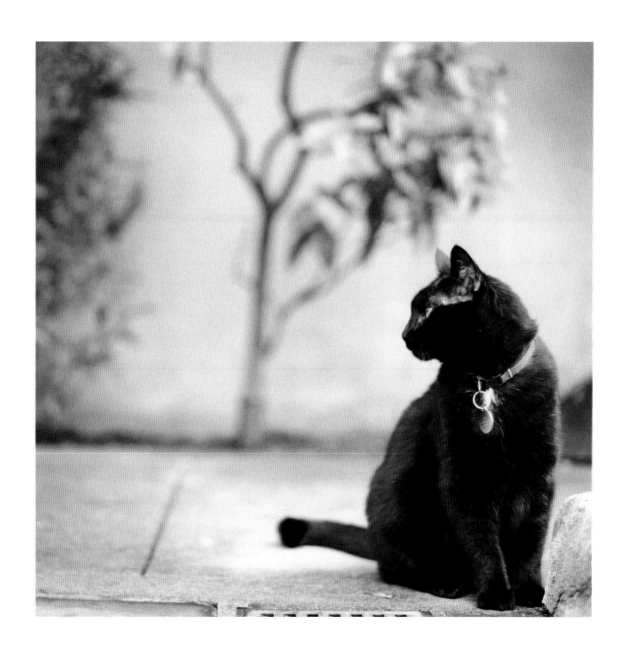

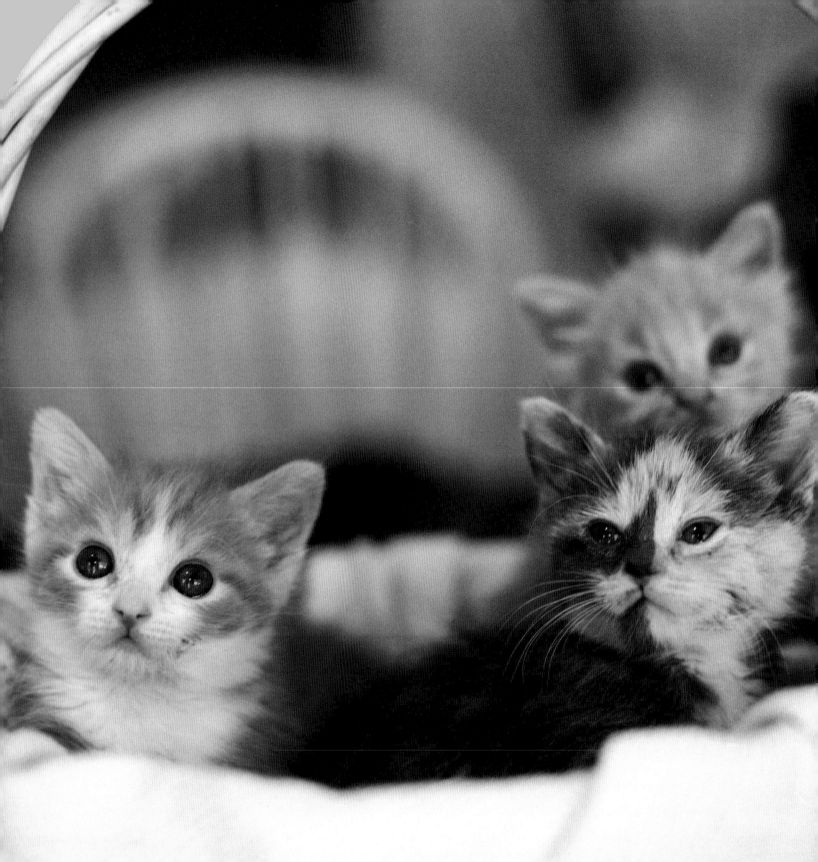

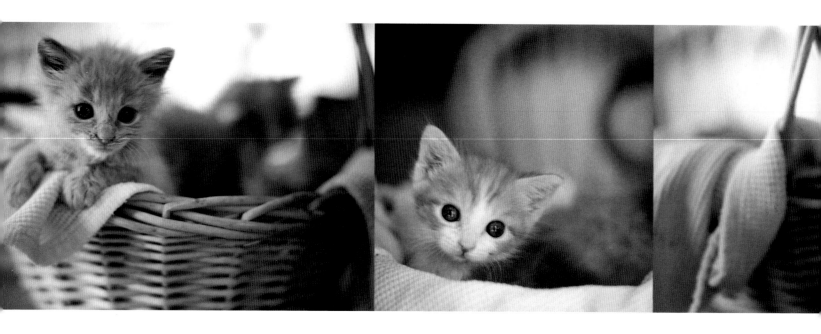

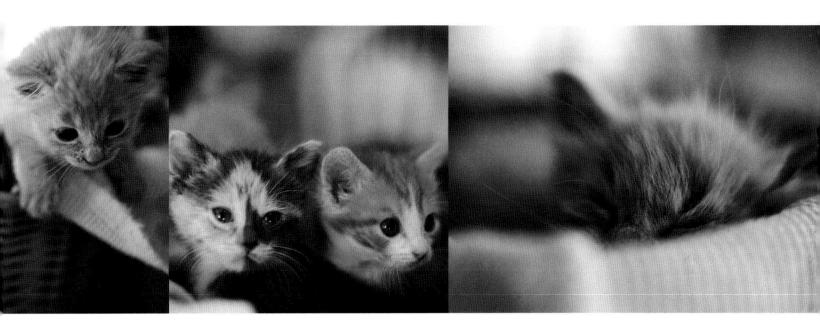

BILLY

(bil'ē)n.

1. hisses

2. growls

3. scratches

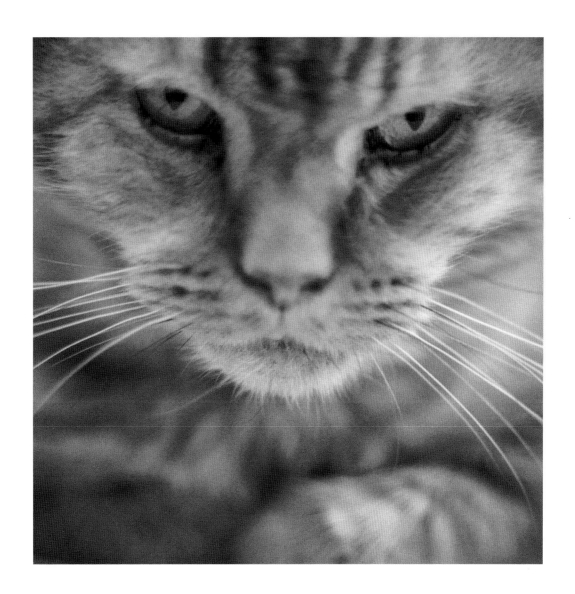

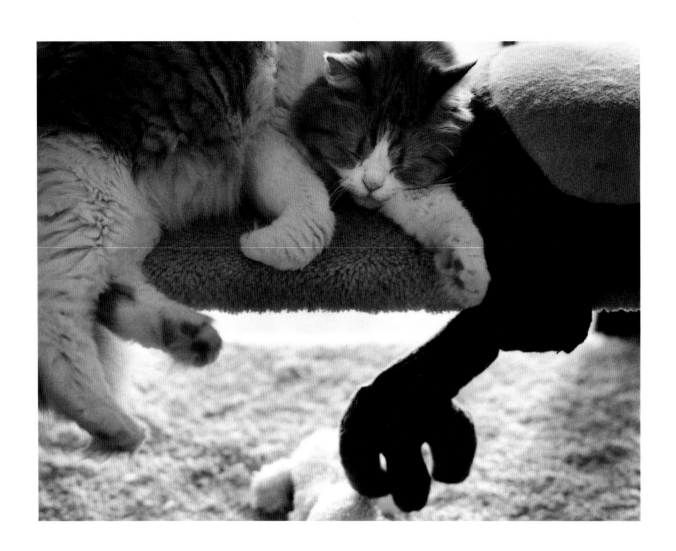

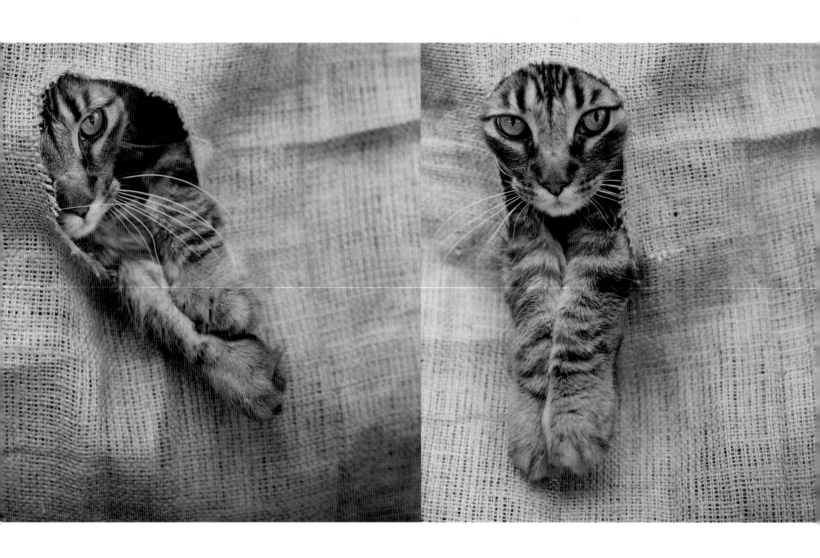

COMET (käm′it)n. 1. Requests 2. Bigger 3. Hole

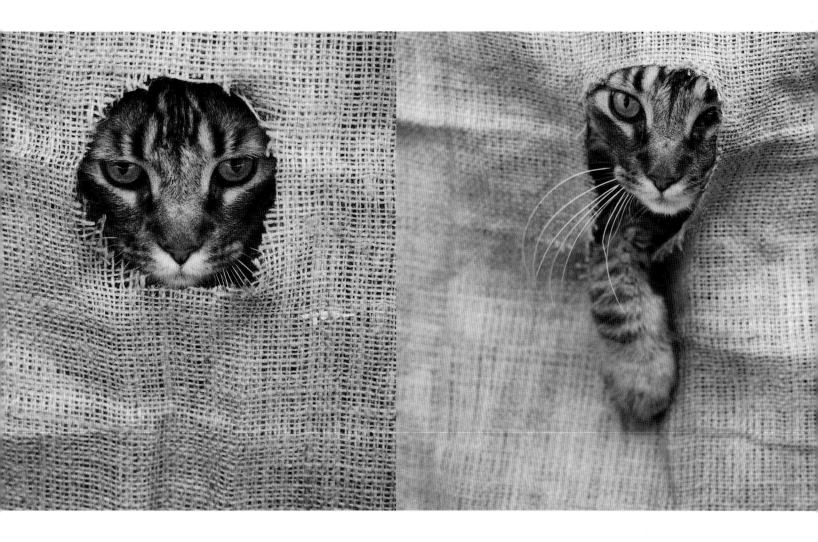

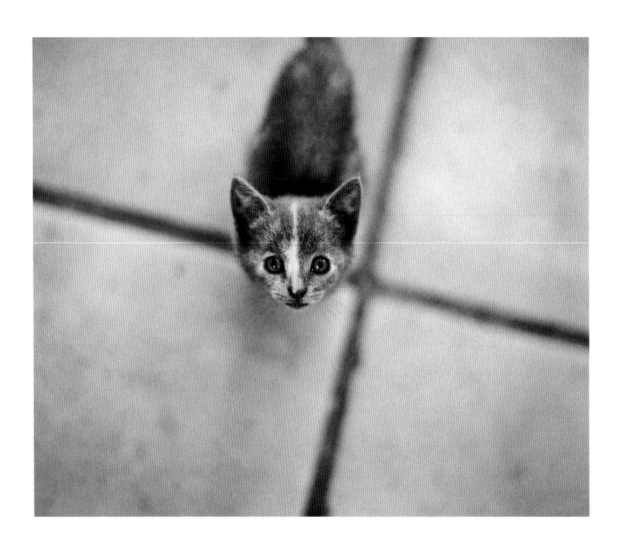

ELVIN

(el'vin)n.

1. sits on the chair

2. sleeps on the chair

3. CHEWS ON THE CHAIR

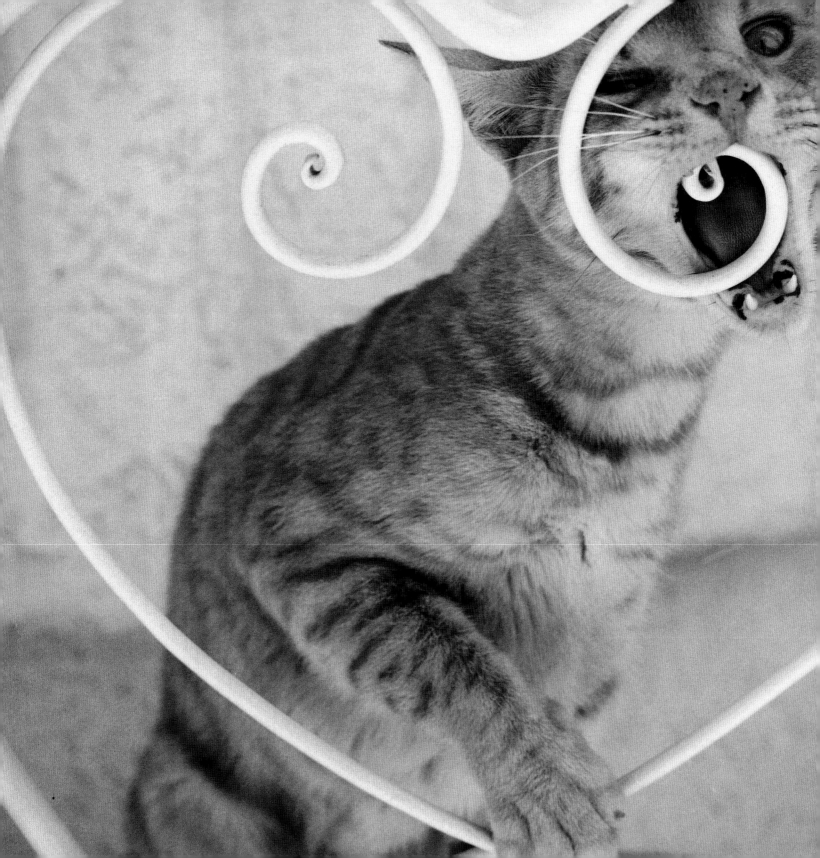

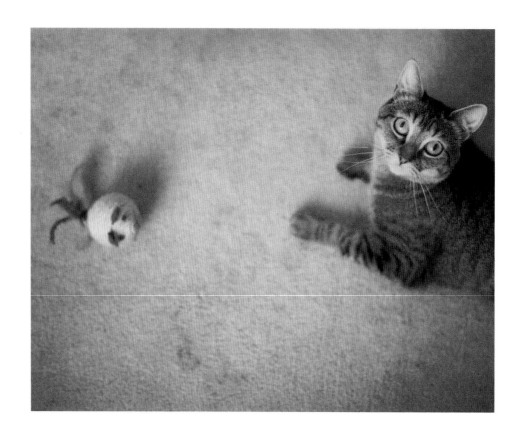

FANNIE

(fan'ē)n.

1. self-centered

2. self-sufficient

3. self-cleaning

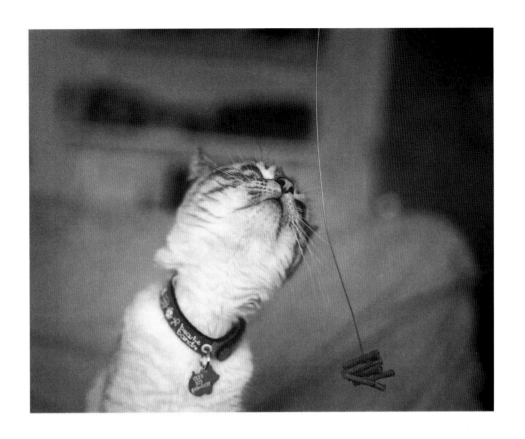

FENNEL

(fen'əl)n.

1. Cute

2. Curious

3. Complex

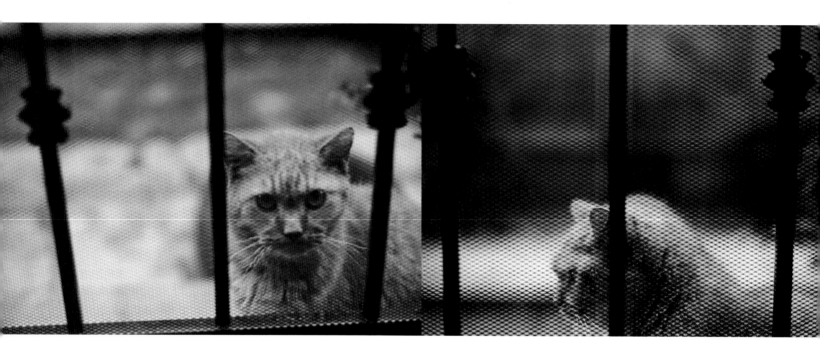

FRITZ (fritz)n. 1. goes OUT at nine 2. comes HOME at five 3. expects DINNER ON TIME!

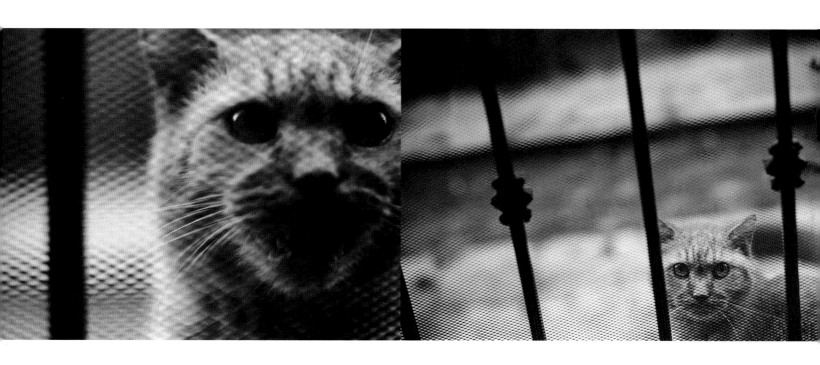

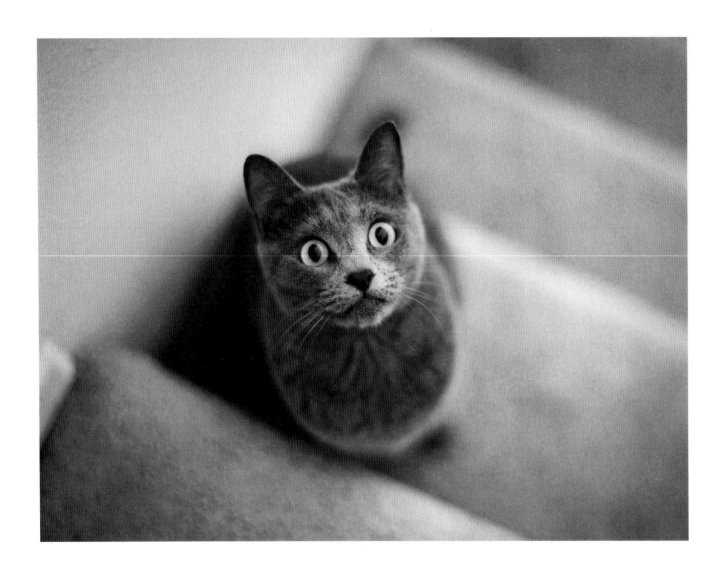

GRACiE

(grās'ē)n.

1. STAYS focused

2. MAINTAINS eye contact

3. ALWAYS gets her way

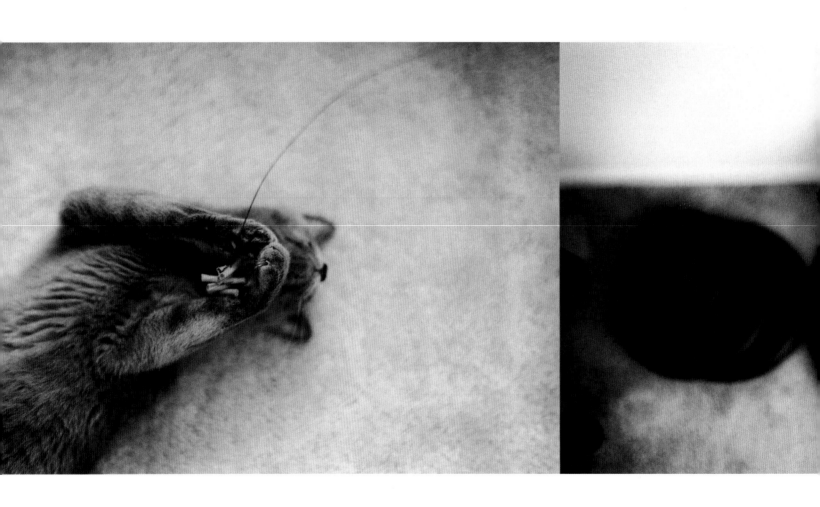

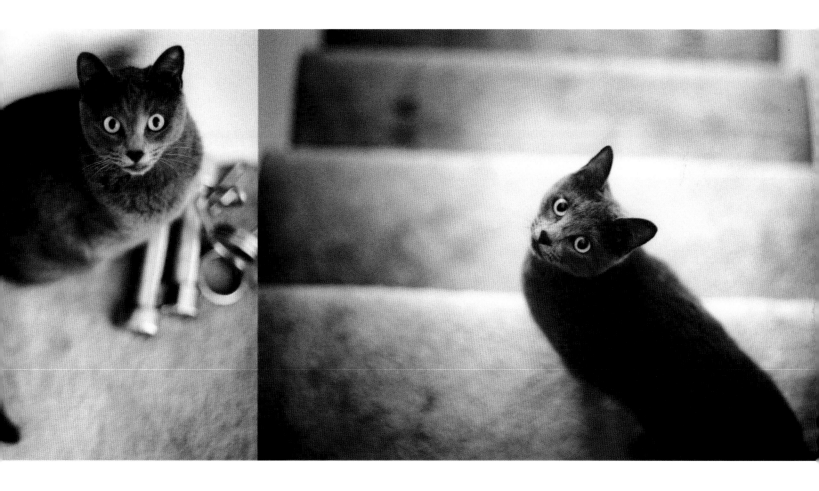

HANK

(hank)n.

1. The FBI 2. The Highway Patrol

3. The Neighborhood Watch

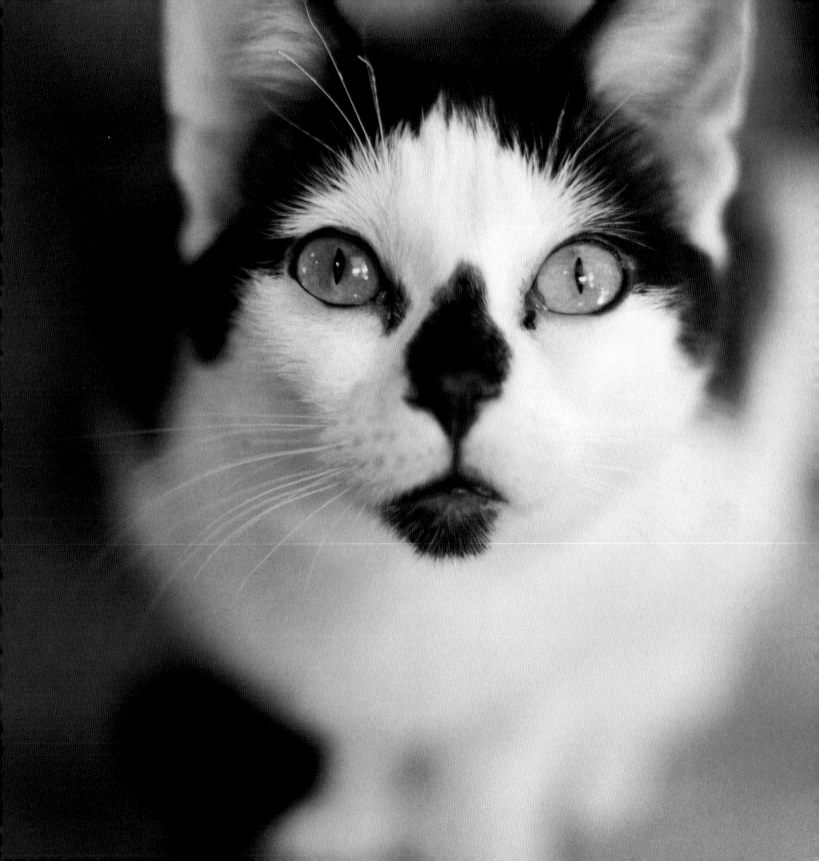

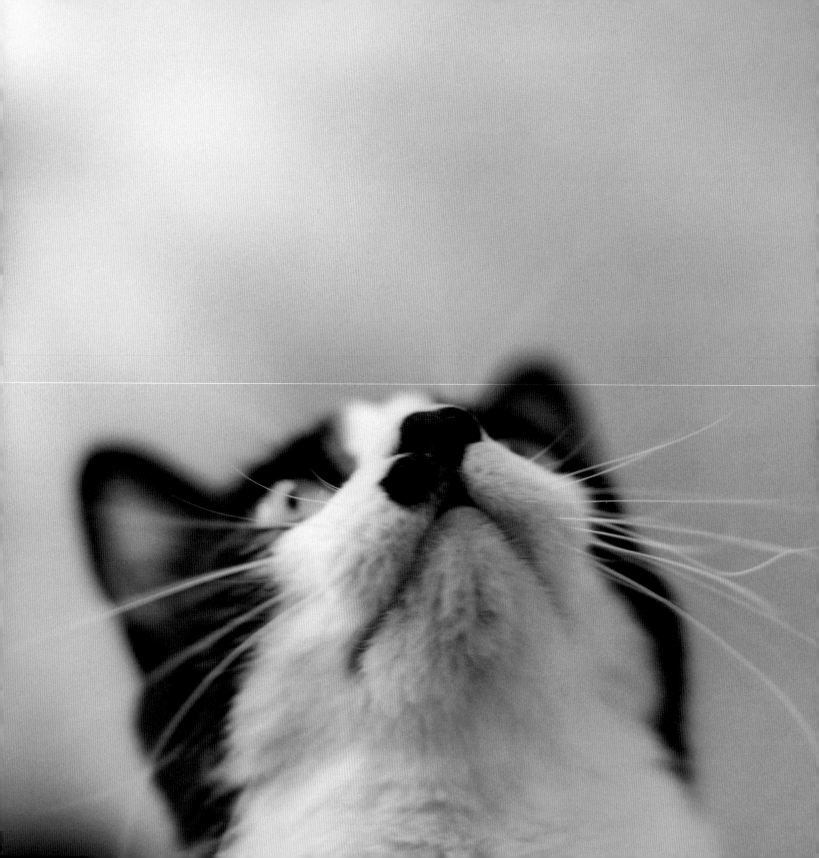

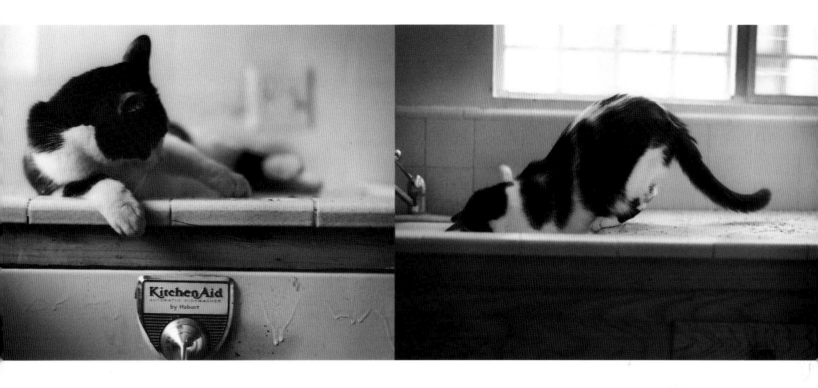

HARLEY
(här' lē)n.

1. will beg for food

2. will plead for food

3. will CLEAN for food!

HUMPHREY

(hum' frē)n.

1. Climbs up

2. Settles in

3. Enjoys the view

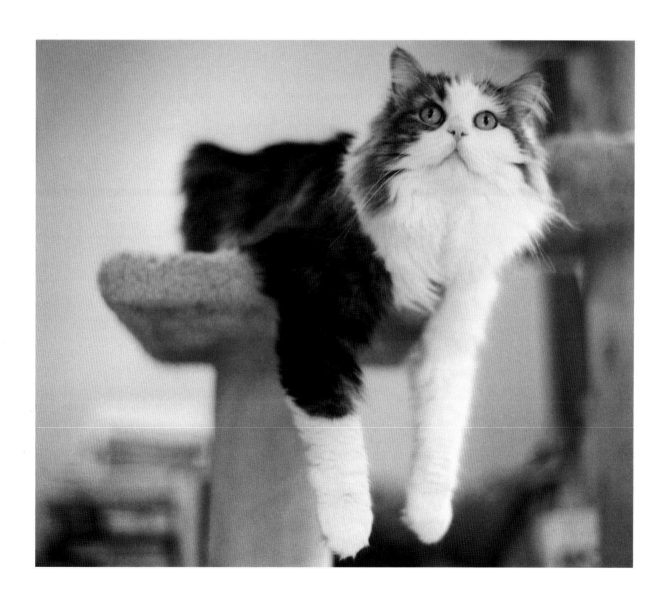

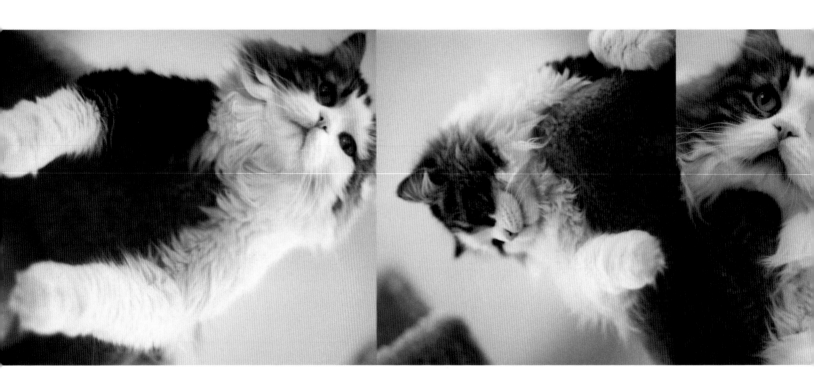

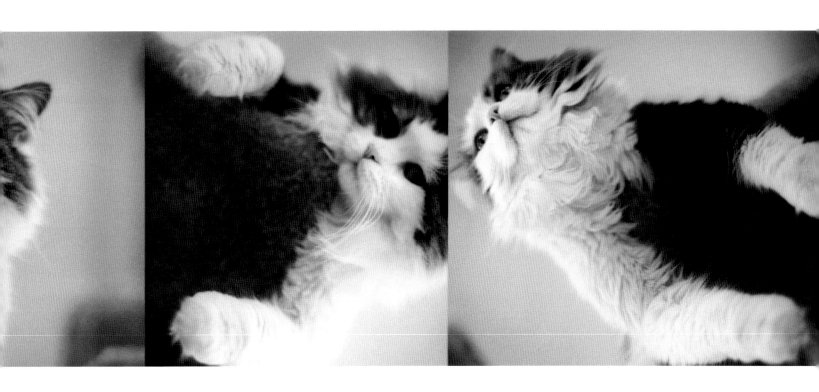

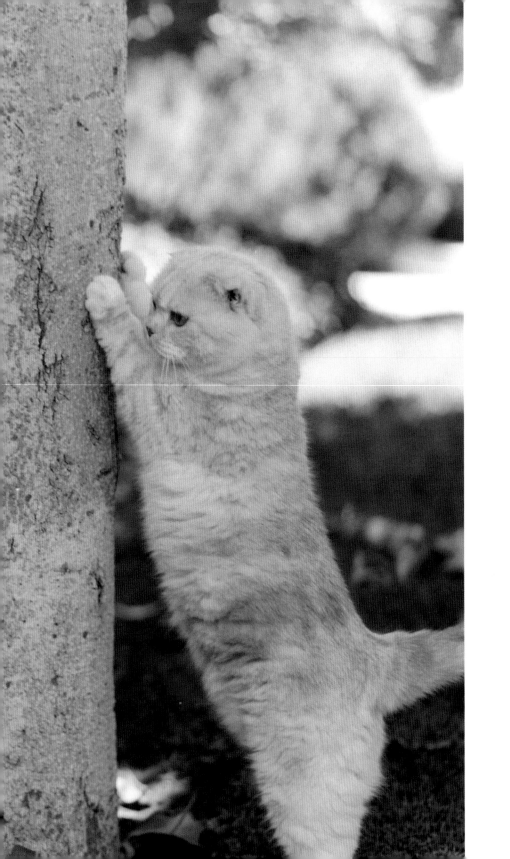

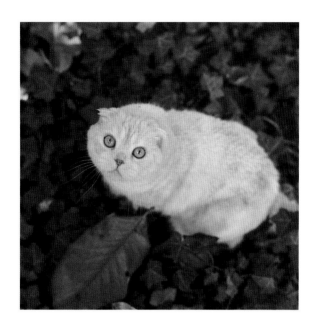

IRIS

(ī'ris)n.

1. trims trees

2. rakes leaves

3. REFERENCES AVAILABLE

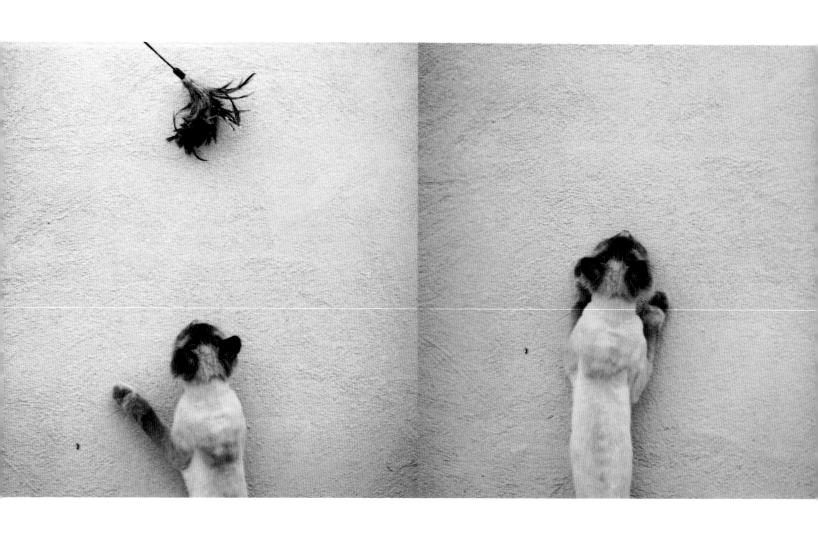

JINO (jēn'ō)n. 1. It's a bird 2. It's a plane 3. It's a FEATHER DUSTER!

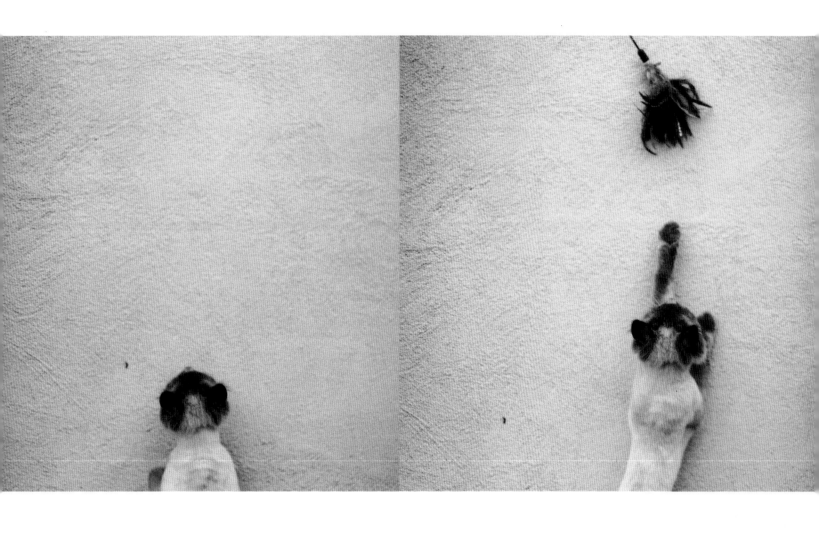

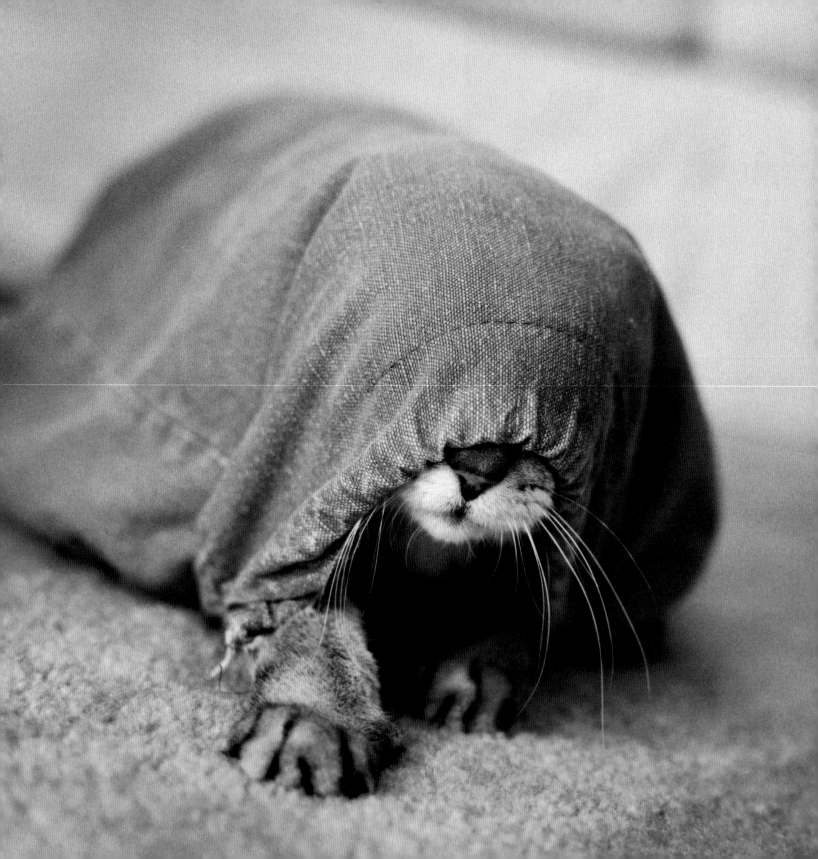

KAHLUA

(kə'lōō ə)n.

1. No

2. Pictures

3. Please!

KNOX

(näks)n.

1. GUARD

2. ON

3. DUTY

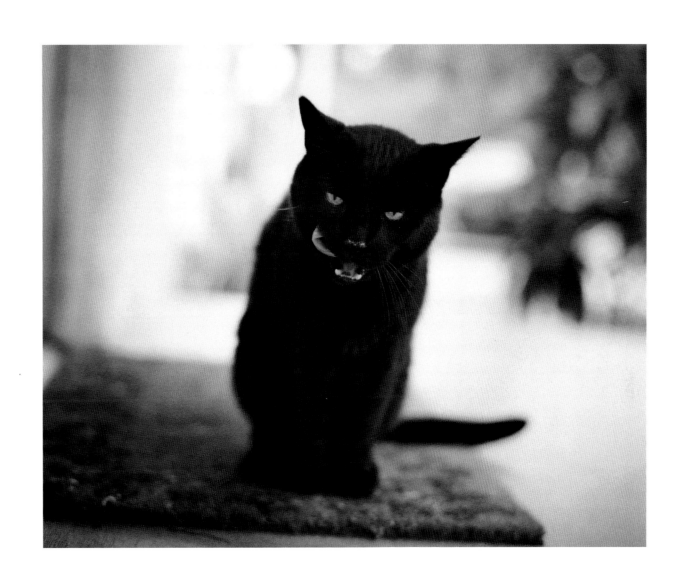

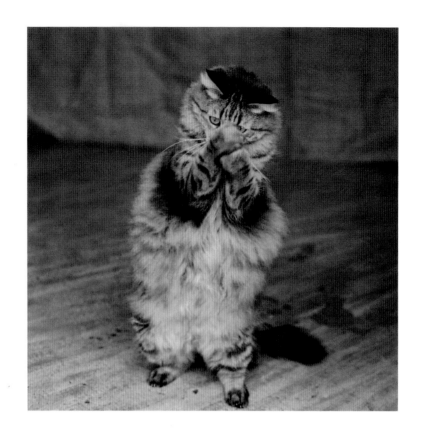

LADY
(lād'ē)n.

1. Put 'em up

2. Put 'em up

3. Put 'em up

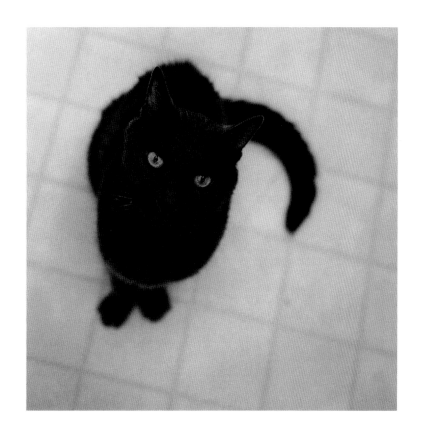

LATTE
(la tā')n.

1. iced

2. decaf

3. nonfat

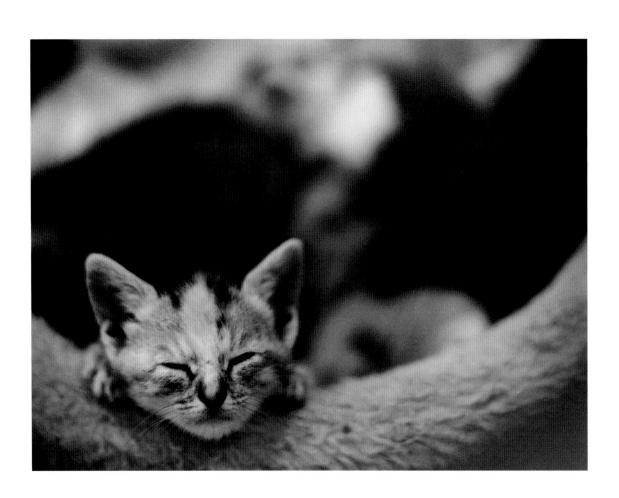

LEWIS

(lōō′əs)n.

1. eats SOME of the day

2. plays PART of the day

3. sleeps MOST of the day

MIDNIGHT

(mid'nīt)n.

1. twelve

2. o'

3. clock

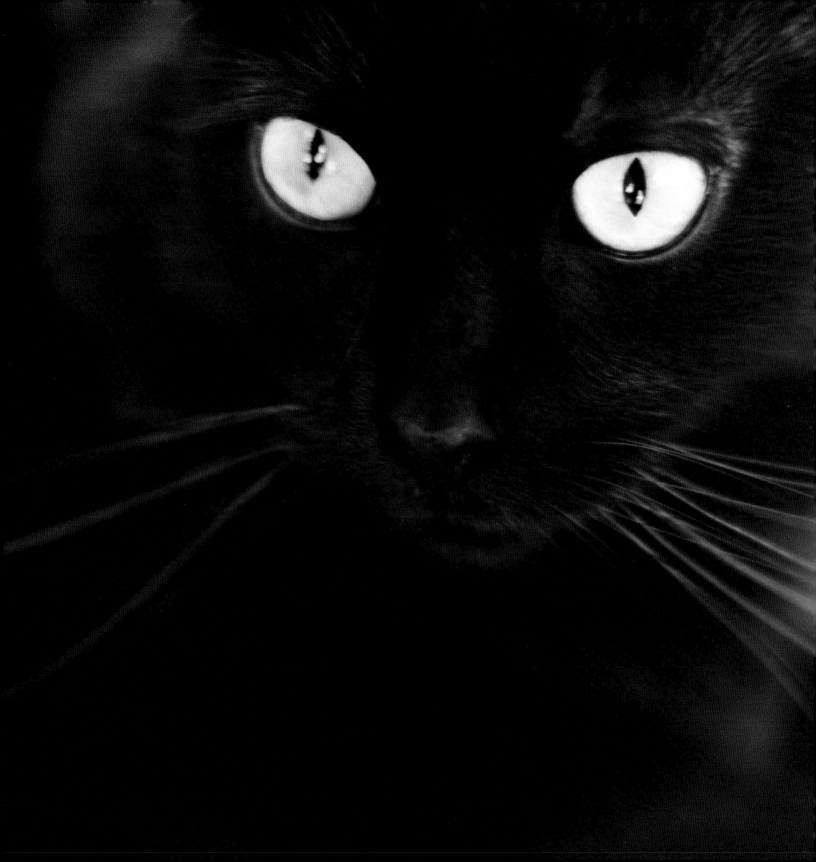

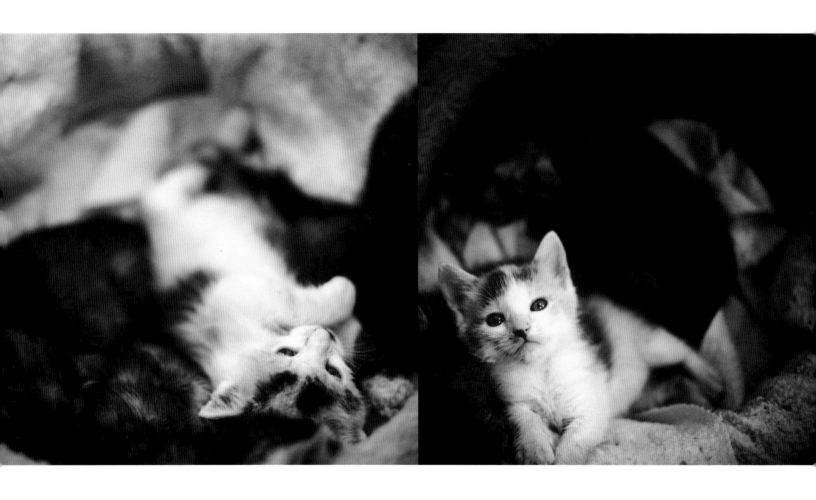

MUFFiN (muf'ən)n. 1. sugar 2. spice 3. everything nice

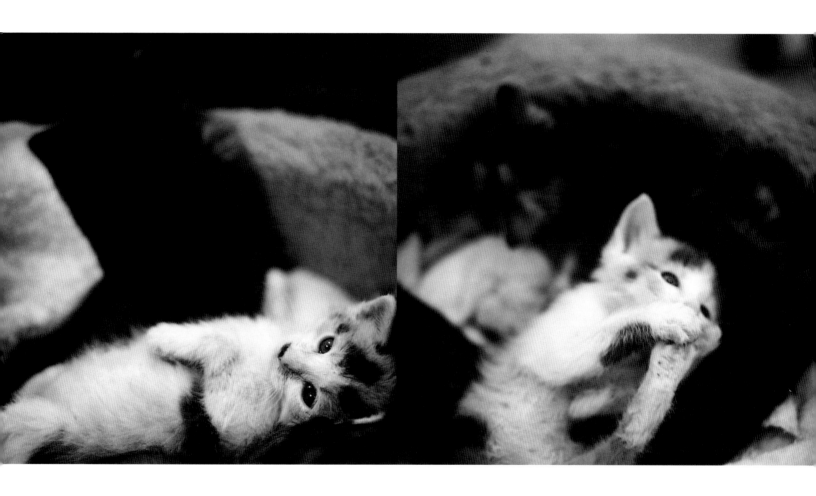

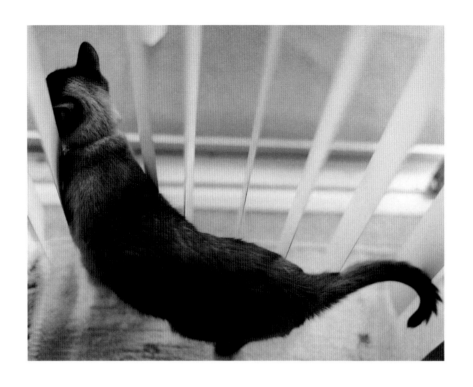

NEWMAN
(n\overline{oo}'men)n.

1. asks to go outside

2. waits to go outside

3. demands to go outside

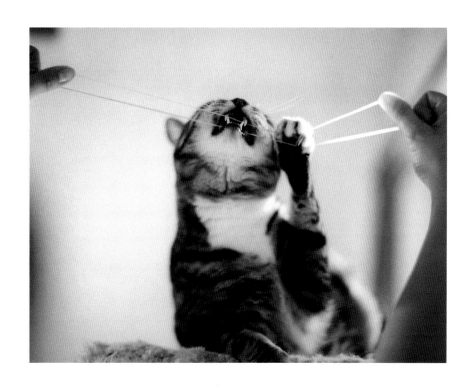

OMELETTE

(äm'ə lit)n.

1. swiss cheese

2. cheddar cheese

3. STRING CHEESE!

OZZIE & PEPPER

(ä'zē, pep'ər)n.

 1. a duo

 2. a pair

 3. a team

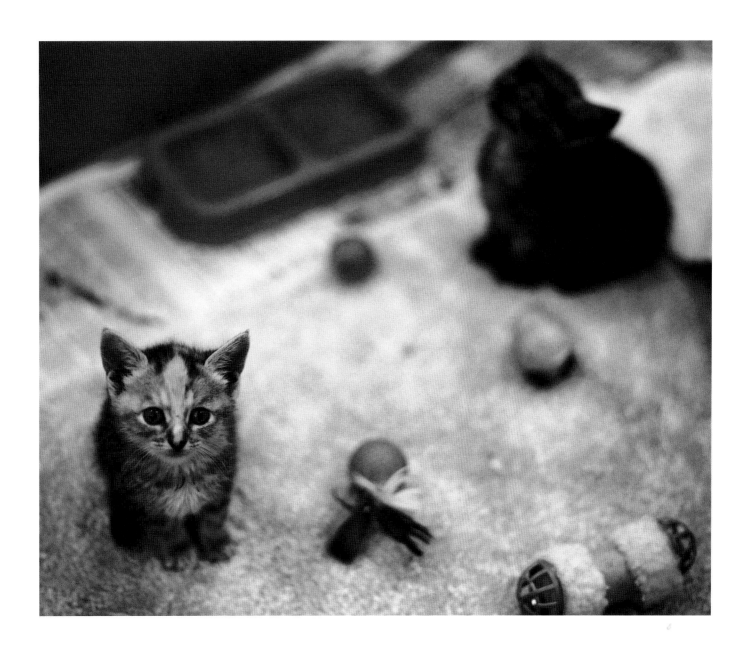

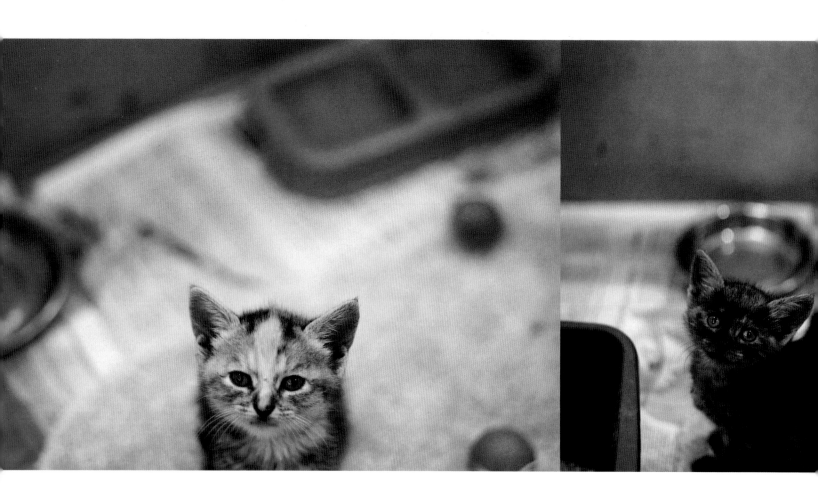

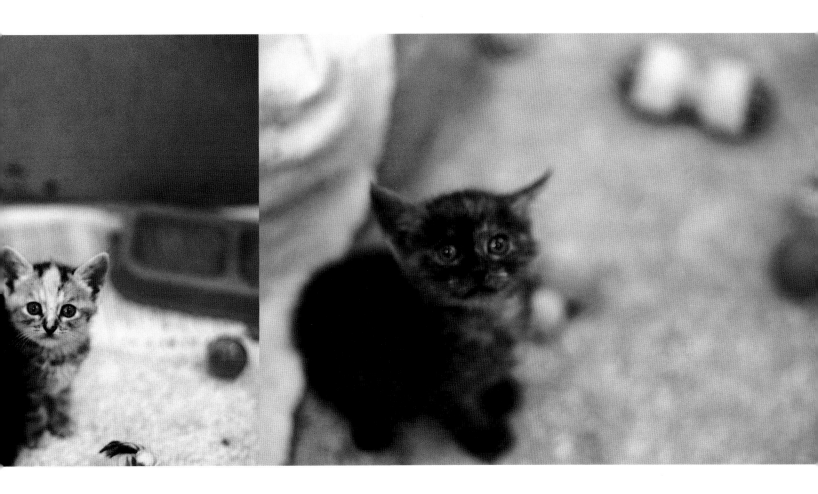

PIGLET

(pig' lit)n.

1. a pain reliever

2. an antidepressant

3. NO PRESCRIPTION NEEDED

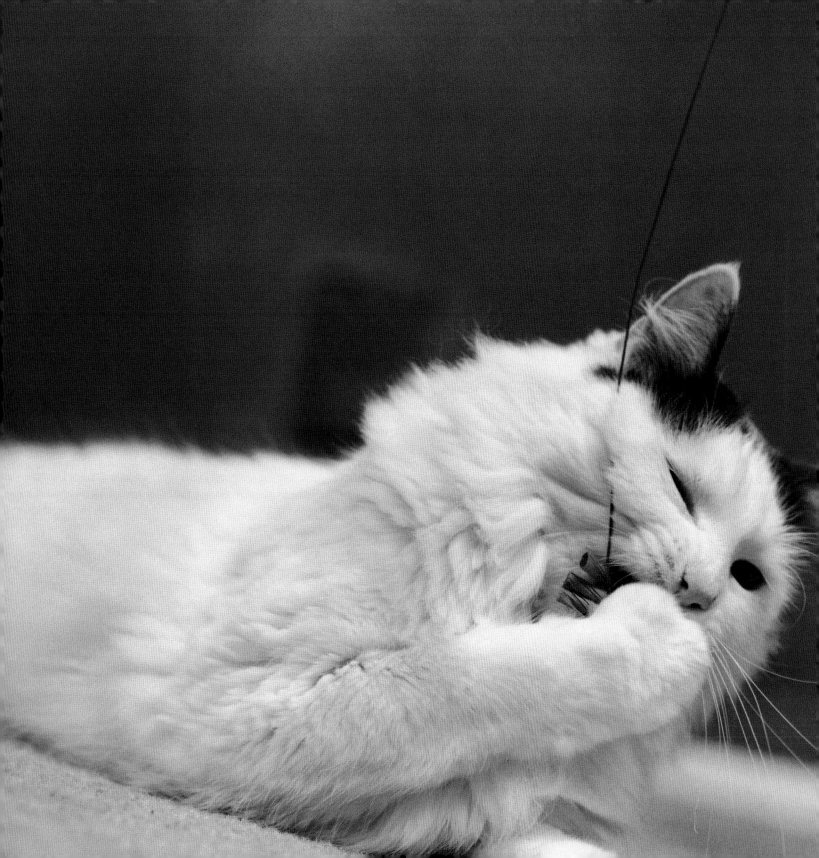

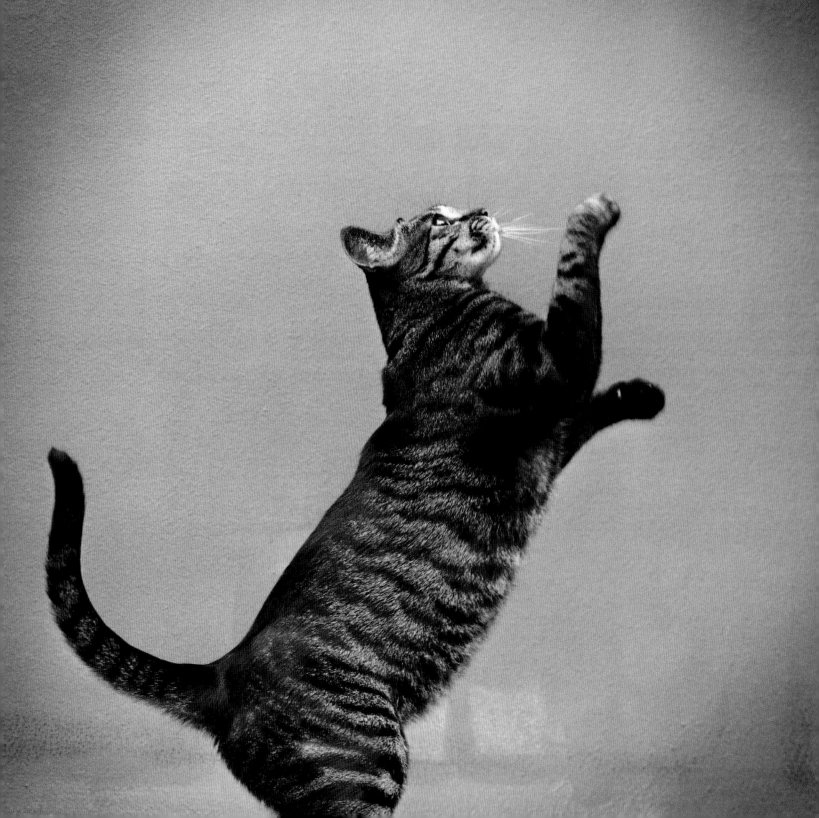

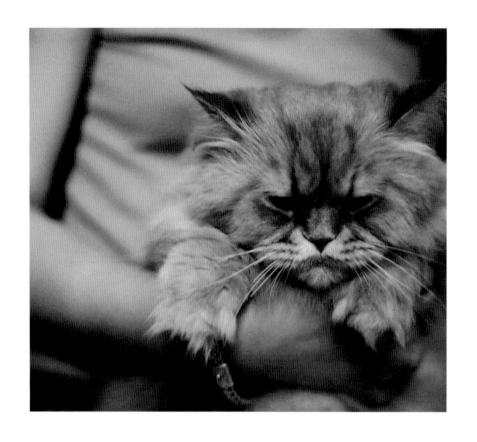

PUMPKiN

(pump'kin)n.

1. a baby boy

2. a pretty boy

3. a mama's boy

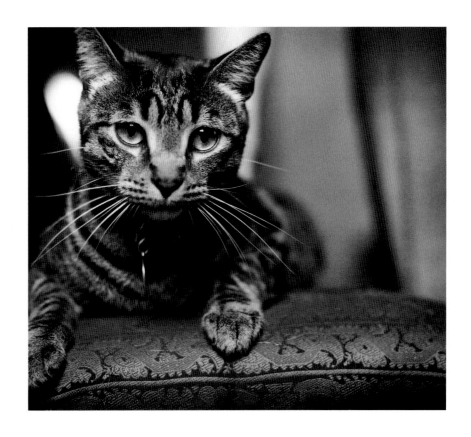

QUEEN
(kwēn)n.

1. ahi tuna

2. bottled water

3. handmade pillows

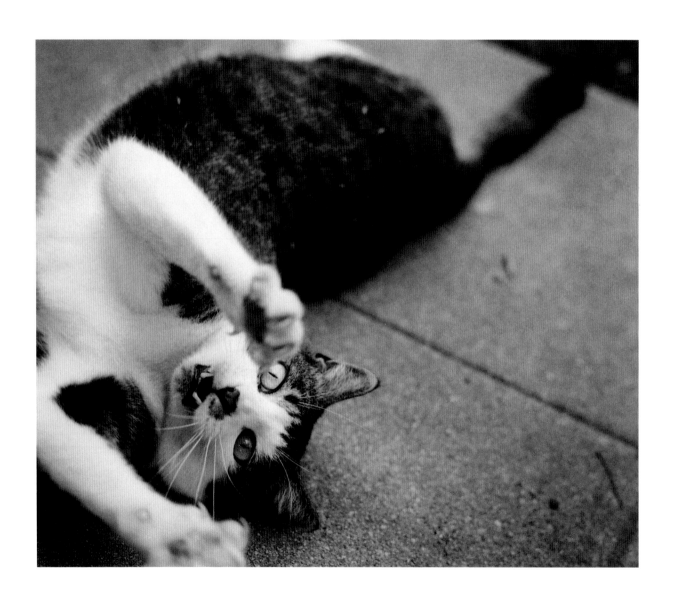

RIPLEY
(rip' lē)n.

1. Razor Claws

2. Needle Teeth

3. Lightning Fast

ROMEO

(rō'mē ō)n.

1. wherefore

2. art

3. thou?

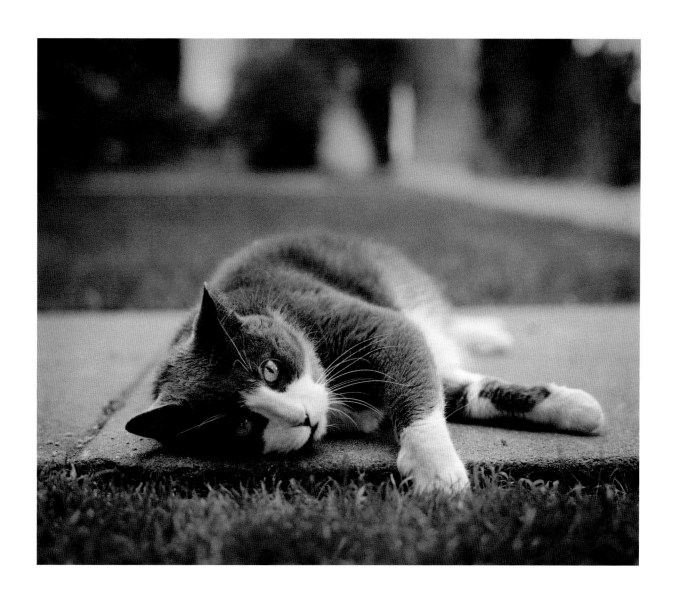

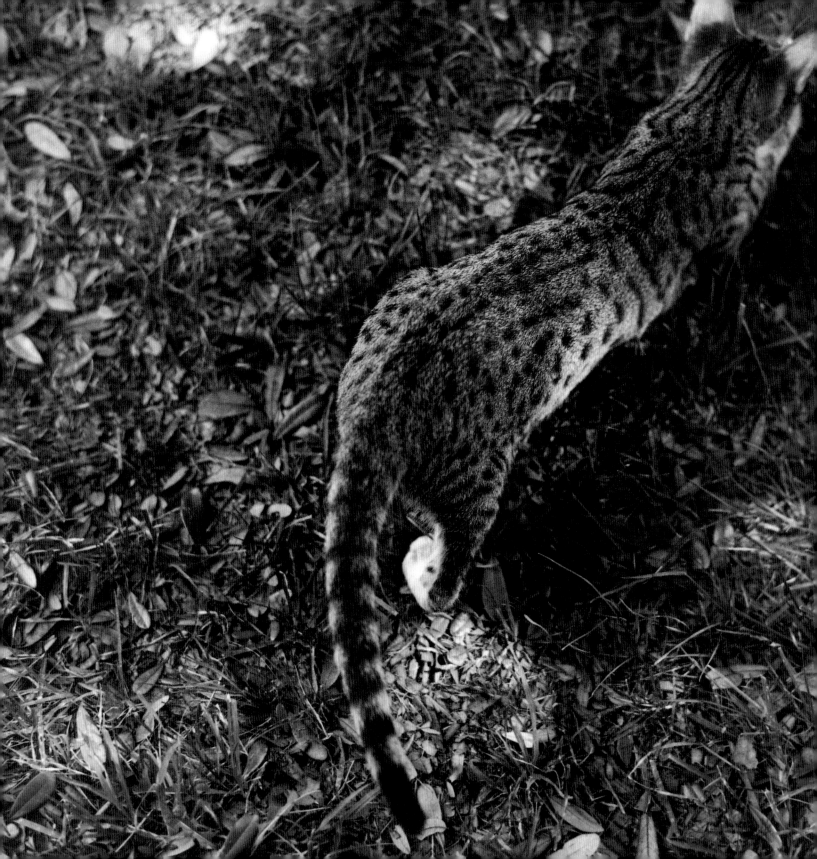

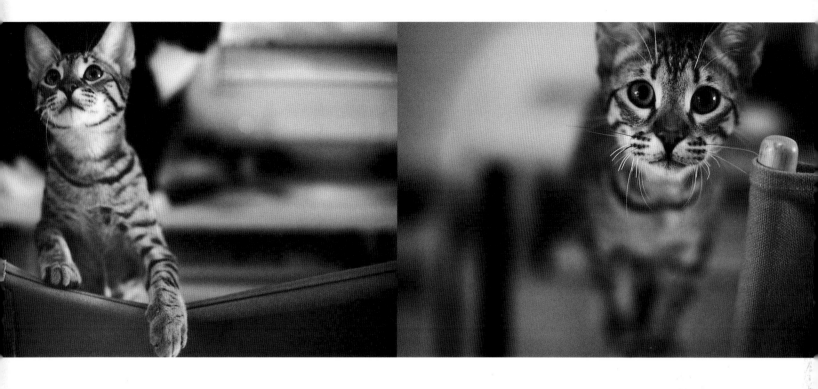

SEBASTIAN

(sə bās'chen)n.

1. Two Eyes 2. Four Paws

3. NINE LIVES

SIBLINGS

(sib'liŋz)n.

1. a shoulder to cry on

2. a shoulder to lean on

3. a shoulder to sleep on

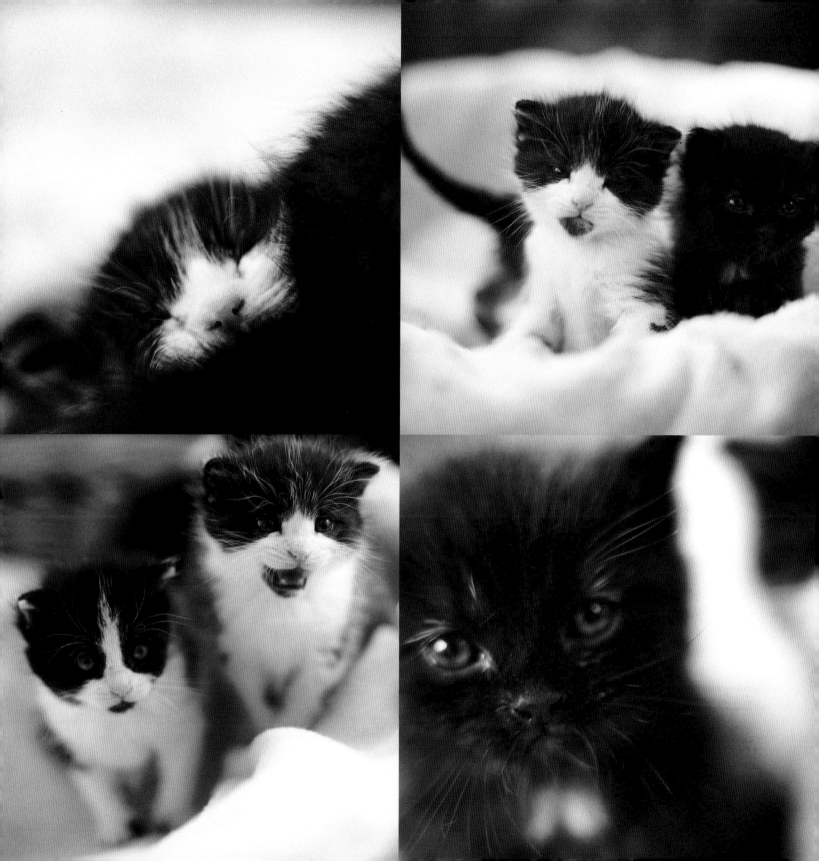

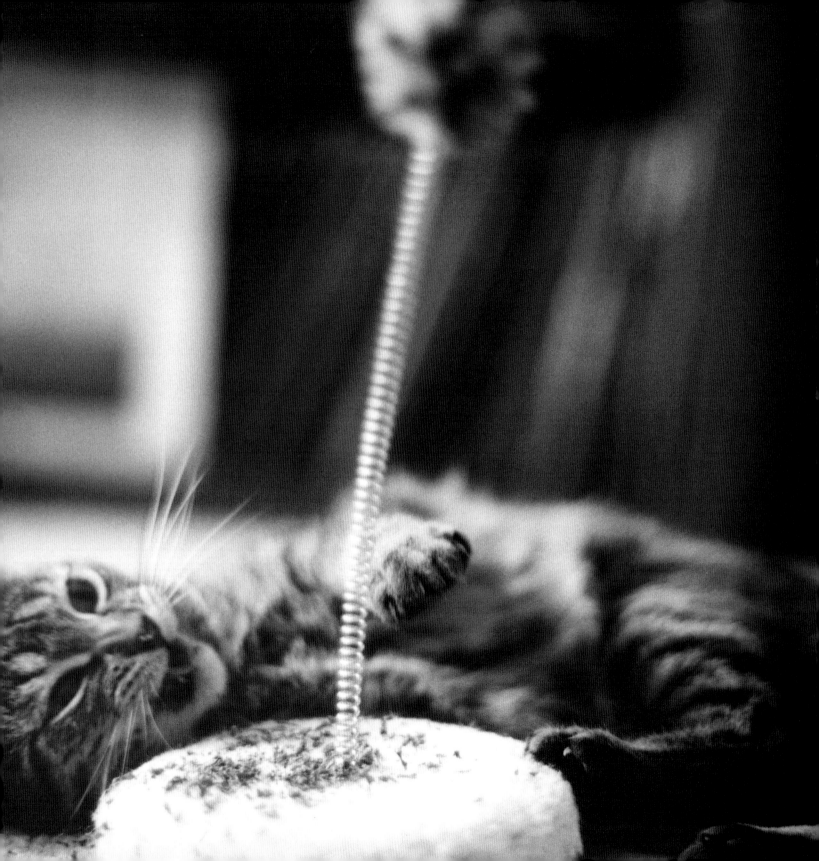

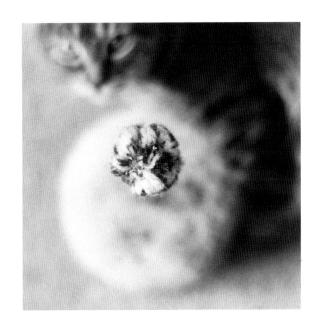

SQUIRT

(skwɑrt)n.

1. favorite place: kitty condo

2. favorite time: dinnertime

3. favorite toy: SPRING BALL!

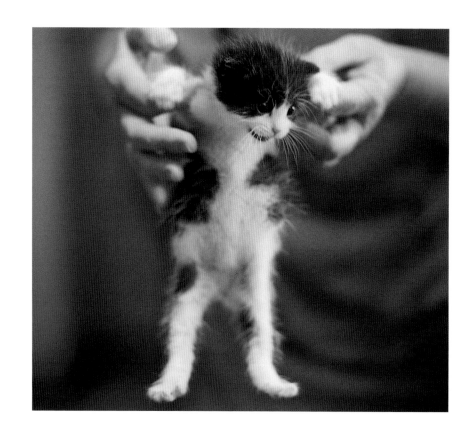

TAxi
(tak'sē)n.

1. brave

2. courageous

3. not AFRAID of HEIGHTS

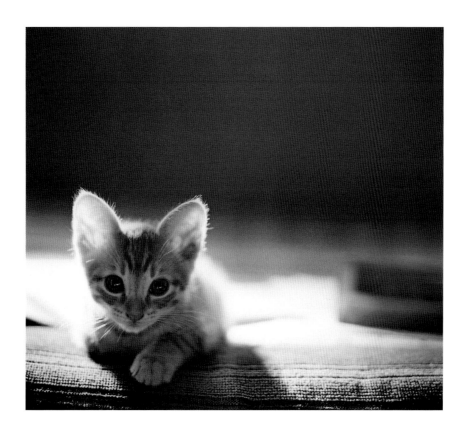

TWINKLE

(tWiŋk'əl)n.

1. twinkle

2. little

3. star

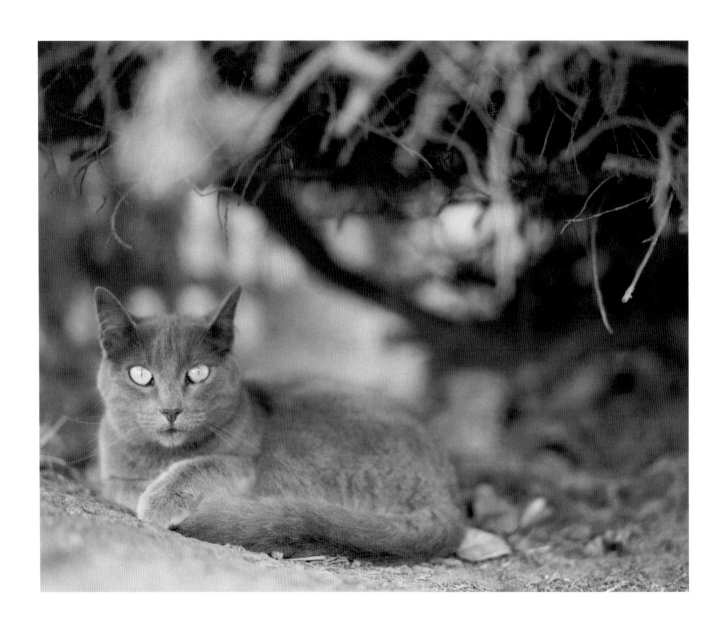

ULYSSES

(yoo lis'ēz)n.

1. Heroic...

2. Majestic...

3. Retired.

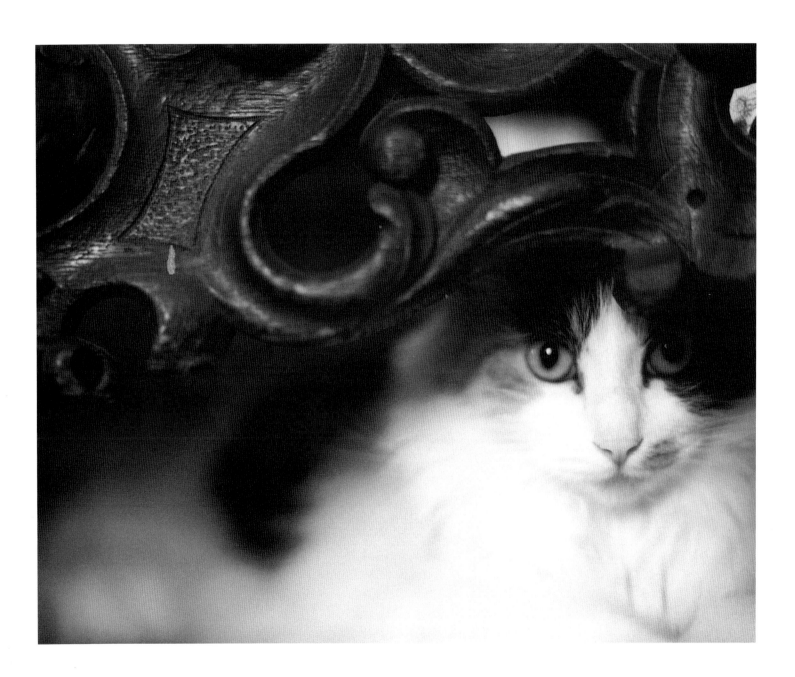

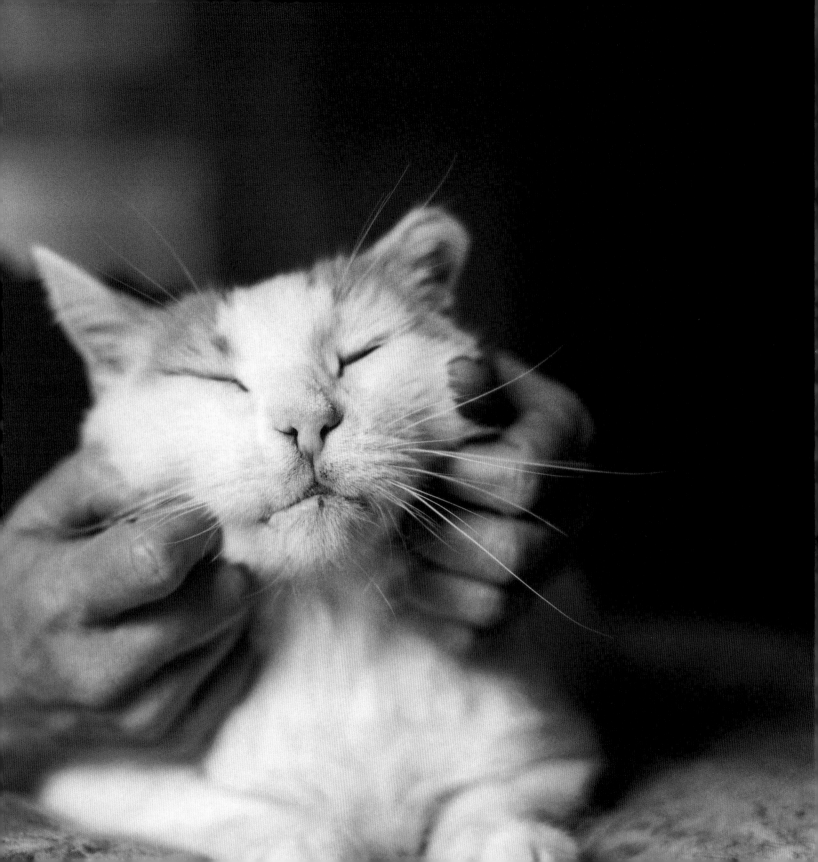

WHITEY
(hwīt'ē)n.

1. pet the head

2. scratch the chin

3. DON'T TOUCH THE TAIL

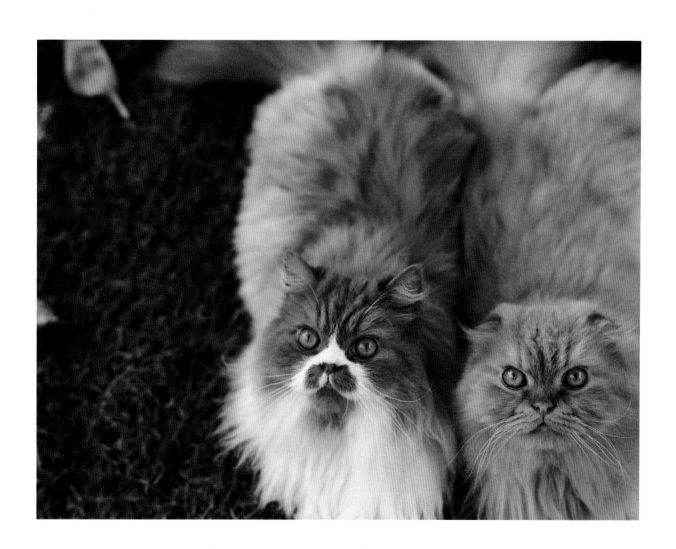

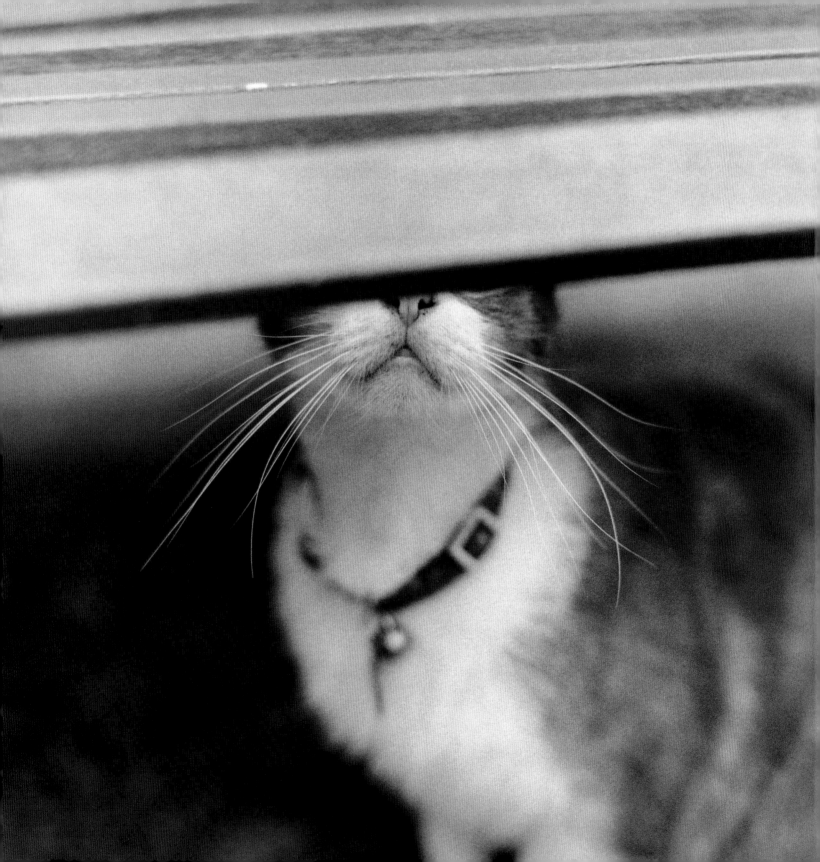

YASMINE

(yaz'min)n.

1. climbs up trees

2. leaps over walls

3. HIDES FROM PEOPLE

ZEKE & ZOEY

(zēk, zō'ē)n.

1. Happily

2. Ever

3. After

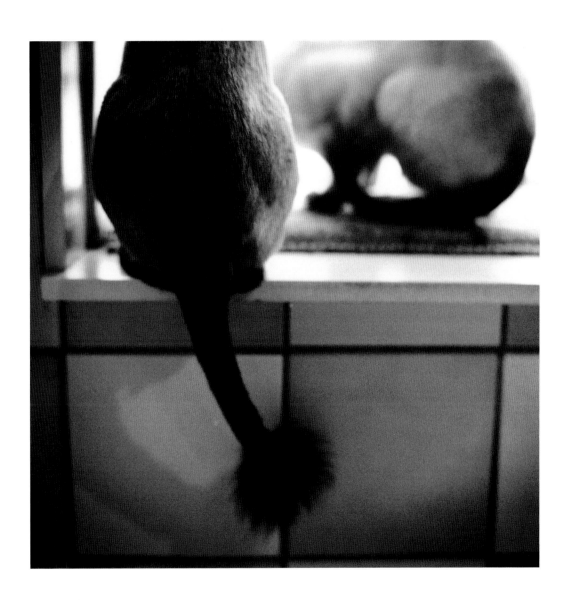

WITH MANY THANKS to my mom, Doris Wise Montrose, for your continued love and support. Also David Montrose, Fela Wise, Marian Montrose, Jack and Annie Montrose, The Sterns, Jenny Hope for being able to make anything happen, and very special thanks to Nancy Martin and Ina Burke for cleaning up my mess! Also Jean Bourget, Carisha Zweigel Gudvi, Johnathan Goldstien, Myk Mishoe, Jackie Lee, Sandy Whaling, Elizabeth Kaltman, all the owners of the cats photographed for this book, Bob Weinberg, and Craig Kovacs for your ongoing loyalty. Also Joseph Viles, i obviously can't thank you enough. Special thanks to my literary agent, Betsy Amster, for making it possible for me to thank you again! i am so grateful to my editors, Christopher Sweet and Michelle Li, and the whole staff at Viking Studio for their continued enthusiasm and for making my books so beautiful. And to the furry little creatures this book celebrates for always waking up from their naps to let me photograph them.